NEWCASTLE-UNDER-LYME
HISTORY TOUR

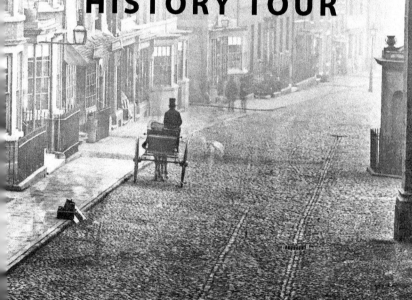

First published 2019

Amberley Publishing
The Hill, Stroud,
Gloucestershire, GL5 4EP
www.amberley-books.com

Copyright © Neil Collingwood, 2019
Map contains Ordnance Survey data
© Crown copyright and database
right [2019]

The right of Neil Collingwood to be
identified as the Author of this work
has been asserted in accordance with
the Copyrights, Designs and Patents
Act 1988.

ISBN 978 1 4456 9288 3 (print)
ISBN 978 1 4456 9289 0 (ebook)

British Library Cataloguing in
Publication Data.
A catalogue record for this book is
available from the British Library.

Origination by Amberley Publishing.
Printed in Great Britain.

INTRODUCTION

The borough of Newcastle-under-Lyme is located in north-west Staffordshire and has boundaries with both Cheshire and Shropshire. The town was not mentioned in the Domesday Survey of 1086, although a charter was granted to the town by Henry II in 1173. Some historians believe that Newcastle did exist when the Norman invasion occurred but was simply included under Trentham. Others believe that the town owes its existence entirely to the building of a motte-and-bailey castle in the 1140s. This castle guarded a fork in the major roads linking London to Carlisle, and Chester. It was required because at that time a civil war was raging between Matilda, daughter of the last Norman king, and Stephen, that king's nephew, and this fork was strategically important. Although only wooden, the castle was well defended by a lake, created by damming the brook at both Pool Dam and Rotter Dam. Part of the castle's motte is still visible behind the bowling green in Queen Elizabeth's Gardens at Pool Dam. In the early 1200s the castle was rebuilt in stone and remnants of the gatehouse can still be seen today in John O'Gaunt's Road.

Over time Newcastle grew outwards from the castle precinct and eventually developed major industries in the mining of coal and ironstone and in the manufacture of fur and felt hats, many of which were finished in London. Although situated close to the 'Staffordshire Potteries', virtually no pottery manufacture was carried out here. The town has been described as the 'Capital of North Staffordshire' because it was where the region's service industry was based – in the form of doctors, lawyers and banks. In the mid-nineteenth century hat manufacturing collapsed virtually overnight, leaving relatively little in the way of industry and today Newcastle serves mainly as a dormitory town for industries in surrounding areas.

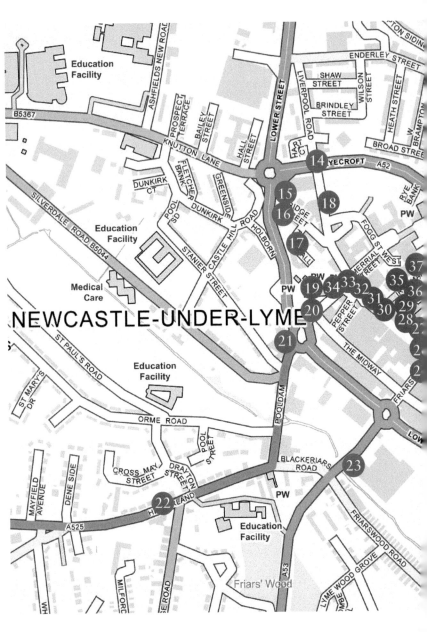

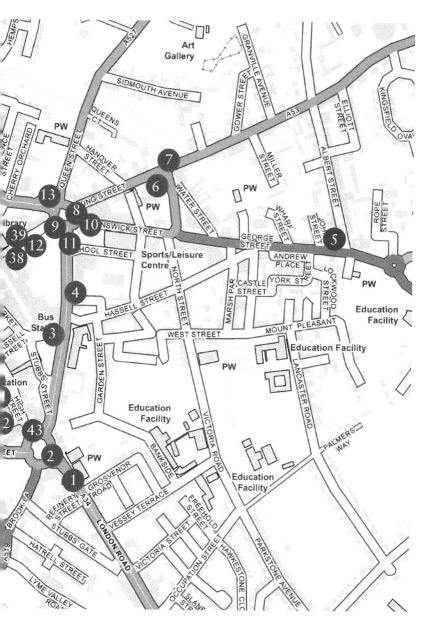

KEY

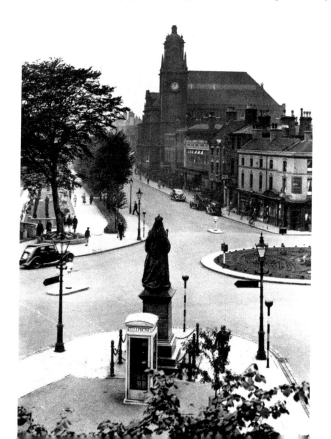

1. APPROACHING NEWCASTLE-UNDER-LYME FROM THE SOUTH, *c.* 1930

This road is now four lanes and the buildings on the left, including F. H. Burgesses agricultural merchants and the three-storey Georgian house beyond, are long gone. The church hall adjacent to Holy Trinity Roman Catholic Church on the right has been demolished and rebuilt, but the buildings directly ahead are still standing. On the right is what would later become the Magnet Café, and to its left the Antelope Inn.

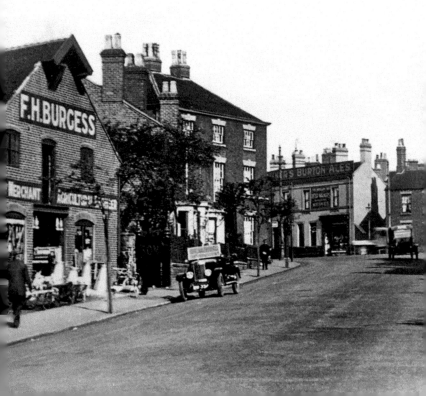

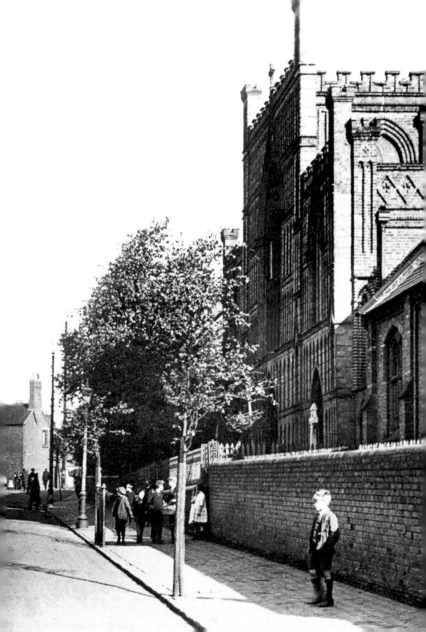

2. JUNCTION OF LONDON ROAD AND HIGH STREET, 1950s

London Road is on the right and the vehicles are parked where the sunken roundabout would be dug in 1964. The Magnet Café, with its painted-on half timbering, had opened and the Antelope Inn to its left had ceased to be a public house. Depending on the precise date when this photo was taken, the street extending into the distance was either Penkhull Street or, after 1 January 1954, the southern part of High Street.

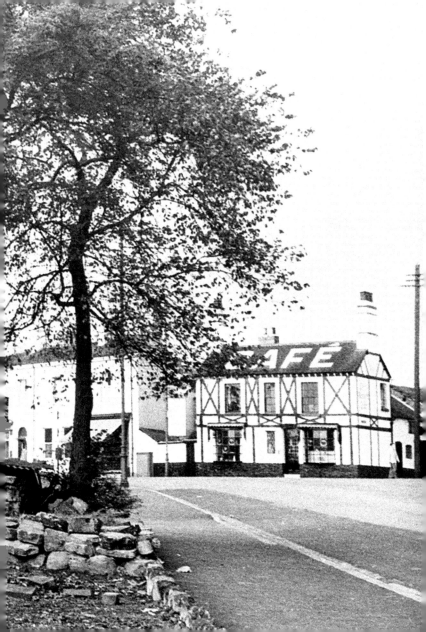

3. HASSELL STREET, 1970s

Although only taken in the 1970s, much of this view has now changed drastically. Maggie's Corner and the rest of its block have been replaced by a Wilkinson's store. The three-storey building beyond this block is now part of H. Samuel's jewellers and the Bird in Hand next door is now a bar called Society. Bow Street, which used to start below the advertising hoarding and curved round into Barracks Road, was covered by the bus station.

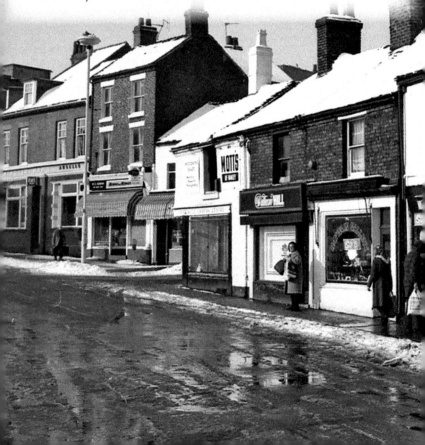

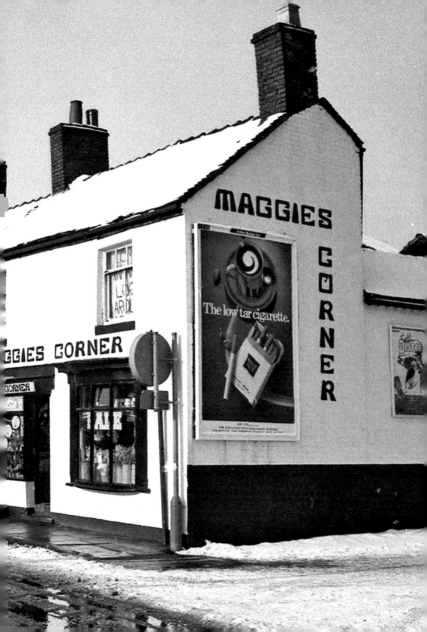

4. BAGNALL STREET, ELEPHANT AND CASTLE BEERHOUSE, *c.* 1910

The only known photo of the Elephant and Castle Beerhouse (a beerhouse could sell beer and cider, but not spirits). In the distance is Nelson Place with its statue of Queen Victoria, and to the right is the roof of the Public Baths. Until 1954 this road was not Barracks Road, as it is today, but Bagnall Street. Marsh & Sons Funeral Directors, situated beyond the Elephant and Castle, are still in business in Newcastle today.

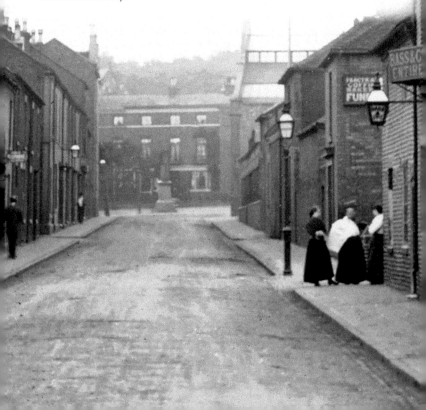

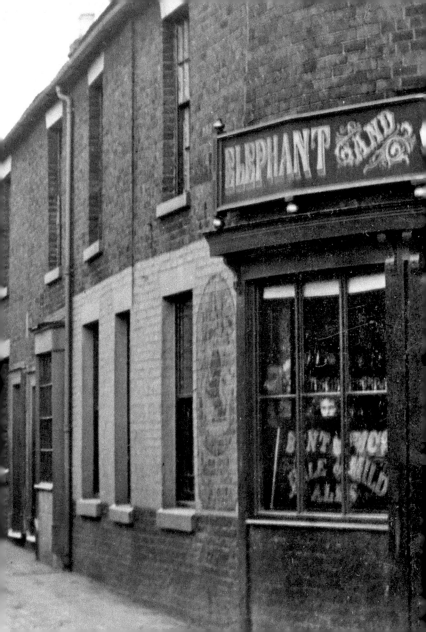

5. GEORGE STREET, c. 1957

Of the buildings here only the Alma Inn (third from left) survives, still serving pints under the same name. Next to the Alma was Lockwood Street, which still exists but no longer reaches George Street. On the other side of Lockwood Street was Sidney Chadwick's radio supplies shop, which moved across George Street when these properties were demolished. The opposite side of George Street, not visible on this view, remains largely unchanged from this time.

6. NEWCASTLE RAILWAY STATION GOODS YARD, 1940s

Another dramatically changed scene shows Water Street on the left, Newcastle station goods yard and St Paul's Church in the distance. In the eighteenth century this view would have included Newcastle's 'upper canal' making its way to its terminus at Stubbs Walks. Today the goods yard has been filled in and is now Borough Road joining King Street to Brunswick Street/George Street. The tip of the spire of St Paul's is just visible above the ultra-modern building.

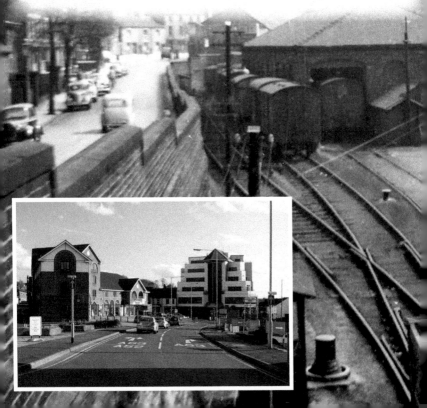

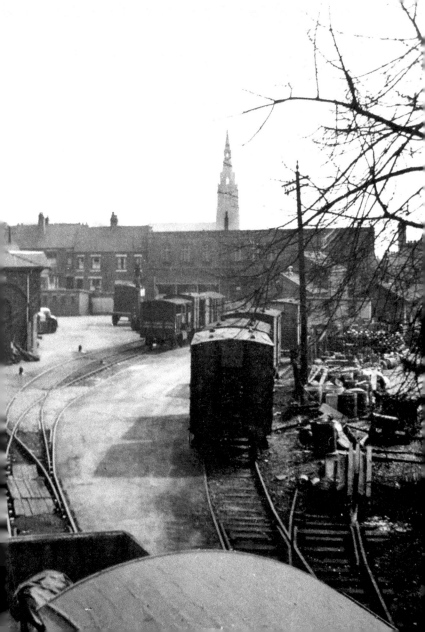

7. NEWCASTLE RAILWAY STATION, KING STREET, 1960s

This 1960s image shows Newcastle's station opposite the Borough Arms Hotel after being condemned by Dr Beeching but not yet demolished. Travelling from Market Drayton both passenger and goods trains would go under the road bridge here, with the passenger line curving left past the hotel and into a tunnel under Albert Street and Basford, and from there to Stoke station. Goods trains would stop immediately behind the station or enter the goods yard (see previous page).

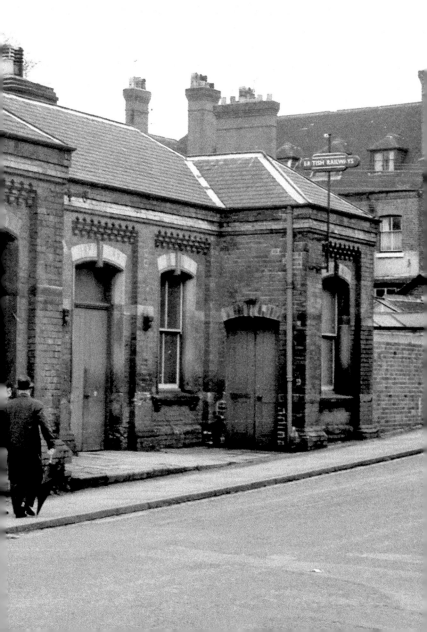

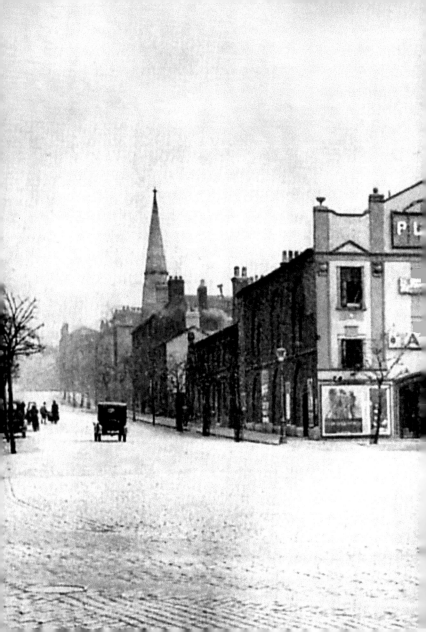

8. PLAZA CINEMA, NELSON PLACE, 1930s

This cinema was originally Newcastle's eighteenth-century theatre before being converted into the Cinema Theatre in 1910. 'Talkies' had just been introduced when this photo was taken, prior to which films were silent and often accompanied by a pianist playing romantic or melodramatic music to reflect the scenes. The Coade stone medallion bearing the head of William Shakespeare, visible on the façade, can now be seen on the front of the New Vic Theatre in Basford.

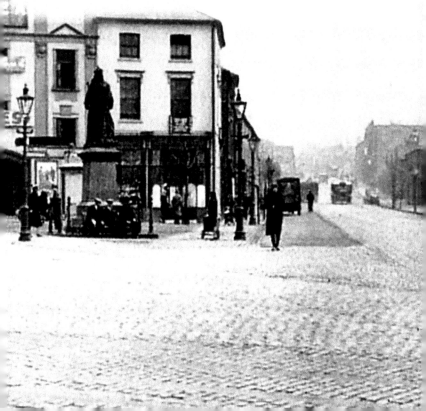

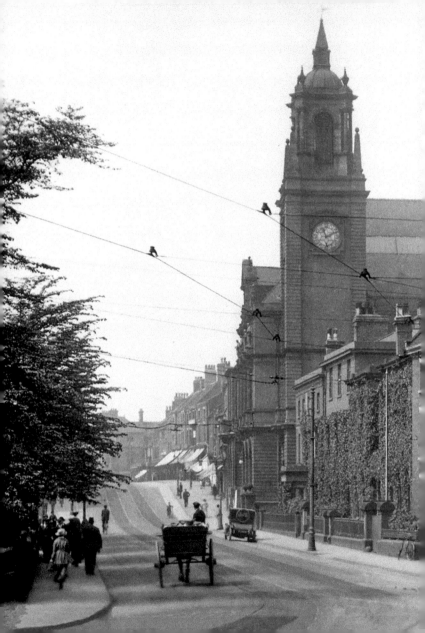

9. IRONMARKET FROM NELSON PLACE, 1920s

This view from Nelson Place up Ironmarket shows the vast range of changes that have taken place in this area. The Compasses pub later became Lace, a so-called 'gentleman's club' and now stands empty. The building further up with a pointed gable was rebuilt, and in the 1930s the Co-op Emporium replaced the ivy-clad building beyond that. The Municipal Hall was demolished in the 1960s and virtually every chimney in the photo has been removed.

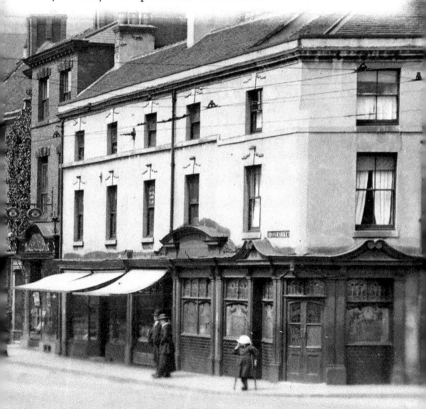

10. BOROUGH TREASURER'S OFFICE, NELSON PLACE, 1966

These three houses, part of the original eighteenth-century formal layout of Nelson Place, had a bust of Admiral Horatio in their central gable, visible in this photo. Although the house was demolished soon after this photo was taken, the bust was preserved, painted and can now be seen in the Borough Museum. In the distance the Municipal Hall can be seen, probably at the time that demolition was temporarily halted owing to the public outcry.

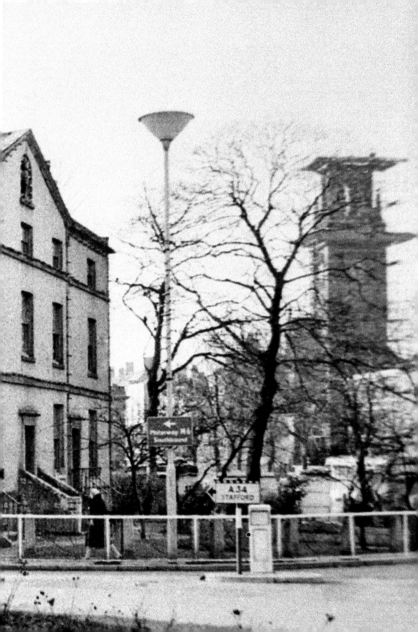

11. BARRACKS ROAD, LOOKING SOUTH, 1967

Prior to 1 January 1954 this was not Barracks Road but Bagnall Street. The original Barracks Road started at Hassell Street and proceeded only as far as the barracks, just visible in the distance. On the right is Bow Street, the other end of which is shown on the image for No. 3. Only the Jolly Potters Inn, Hassell County Primary School, the barracks and a few houses beyond it survive today, everything else having been demolished.

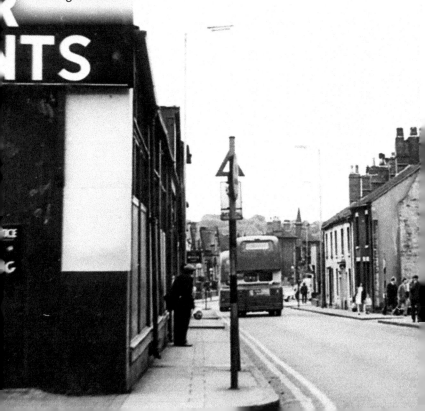

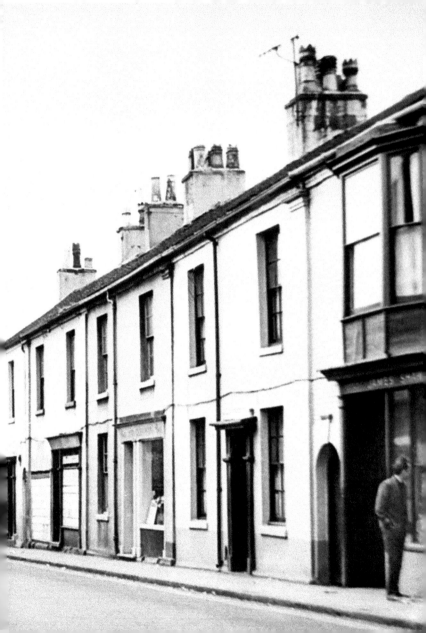

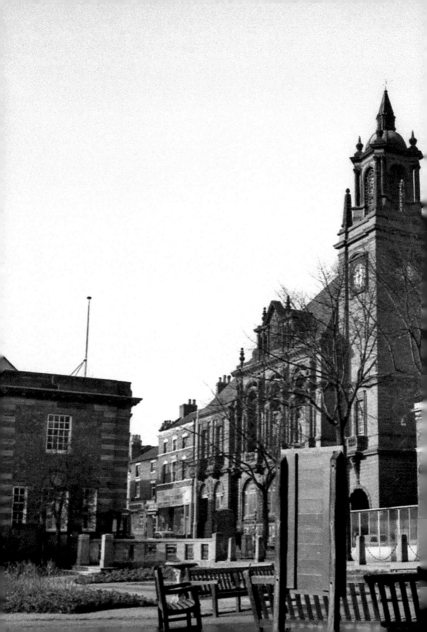

12. IRONMARKET, THE MUNICIPAL HALL FROM THE QUEEN'S GARDENS, EARLY 1960s

The Municipal Hall will eventually become just another part of Newcastle's distant past, but these days its demolition remains the subject most likely to cause anger amongst older Newcastilians. Although built as a 'public building' to replace the Guildhall, which had become too small, the 'Muni' today could never be anything more than an incredibly expensive white elephant for the council to maintain. It is a real shame it had to go though.

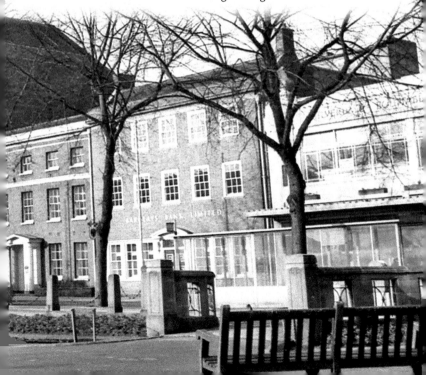

13. NELSON PLACE, THE ROXY CINEMA AND NEWCASTLE SWIMMING BATHS, *c.* 1960

The cinema had changed its name from the Plaza by the time this photo was taken *c.* 1960. Taken from the end of Marsh Street, it shows three major buildings, none of which survive today – the Cinema with the former YMCA and Telephone Exchange next door, the Public Swimming Baths and the Brunswick Methodist Chapel. Queen Victoria's statue was still located in Nelson Place then, but would soon move to relative obscurity in Station Walks.

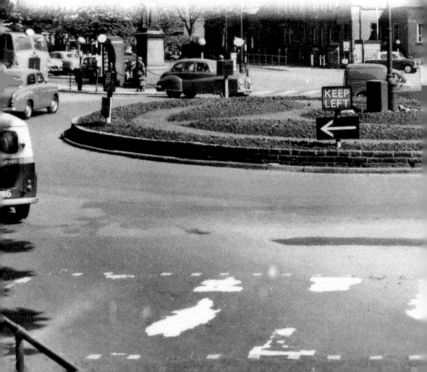

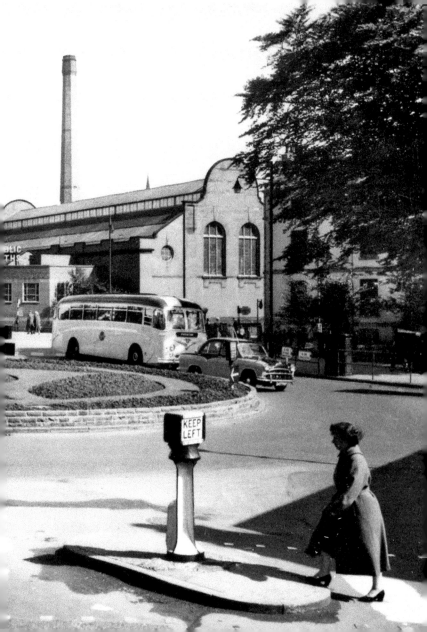

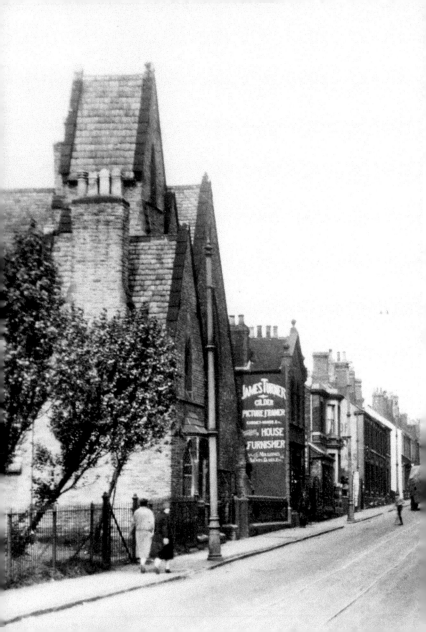

14. ST JOHN'S CHURCH , LIVERPOOL ROAD, 1920s

Through traffic used to enter Newcastle via London Road, pass through the centre, avoiding the busy street market when it was running, and exit to the north via Liverpool Road. The buildings on the left have all been demolished but some of those on the right still survive, including The Albert public house. On the left is St John's Church and on the right is Edwin Harrison's photography studio, which had moved from High Street in 1876.

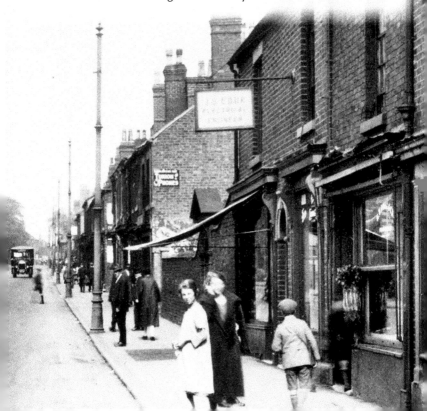

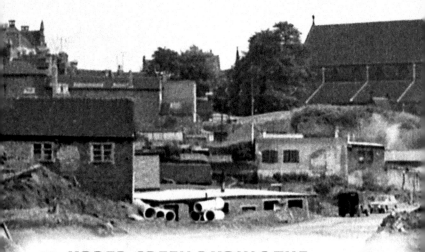

15. UPPER GREEN DURING THE CONSTRUCTION OF THE A34, 1964

This photo from Upper Green shows the ground preparation for the construction of the A34 by-pass in 1964. This area is approximately where the Ryecroft roundabout stands today. St Giles' Parish Church and the Unitarian Meeting House where Josiah Wedgwood used to worship can be seen, as well as the former Bridge Street Arts Centre on the left. On the right is the Dog & Partridge Inn and Holborn Paper Mill, which was later destroyed by fire.

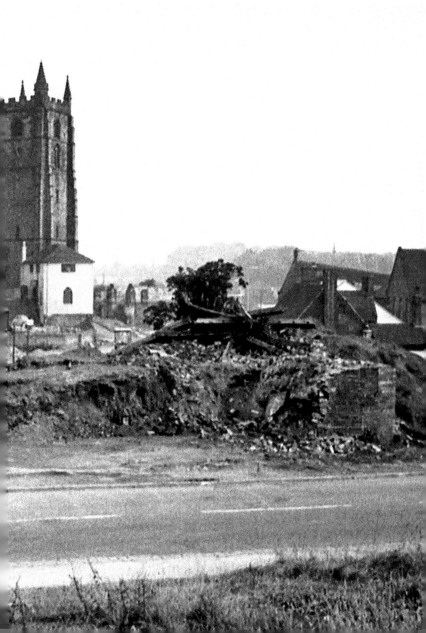

16. BRIDGE STREET, THE ALBEMARLE ALMSHOUSES, 1960s

The Albemarle Almshouses were built in 1743 to house twenty poor widows of the borough. At the rear of the L-shaped building was a small garden where the widows could relax. Both the almshouses and the garden can be seen in the photo taken from the top of St Giles' Church tower (see No. 19). The building was demolished as part of the A34 by-pass development and the area is now occupied by the Ryecroft roundabout.

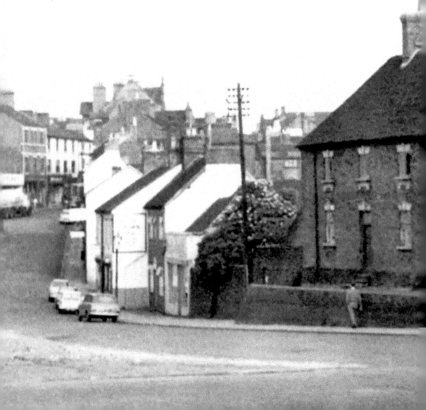

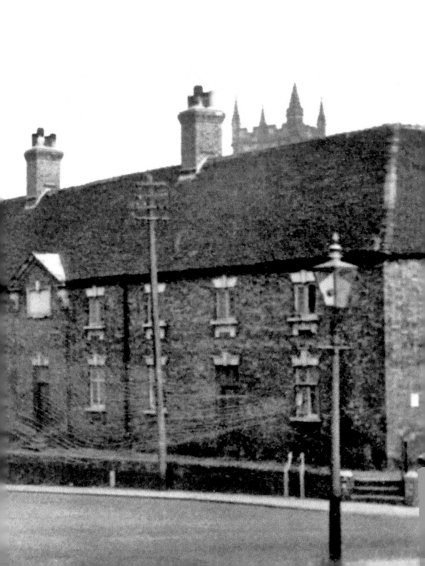

17. FROGHALL, 1935/36

Taken either at the time of George V's Silver Jubilee in 1935 or during one of the events in the Year of the Three Kings (1936), photos of Froghall are scarce. Today Froghall has no housing whatsoever and acts simply as an access road to office units located adjacent to the A34. In the distance the rear of the Old Brown Jug can be seen, and on the opposite side of Bridge Street is the Old Vine Inn.

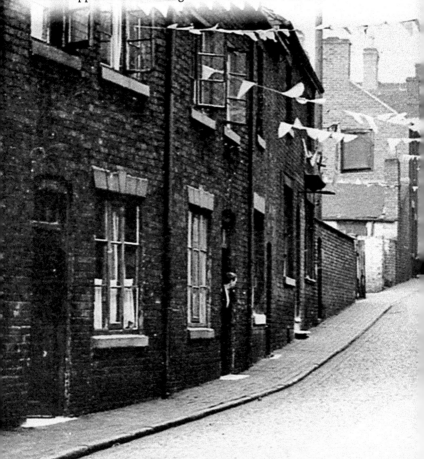

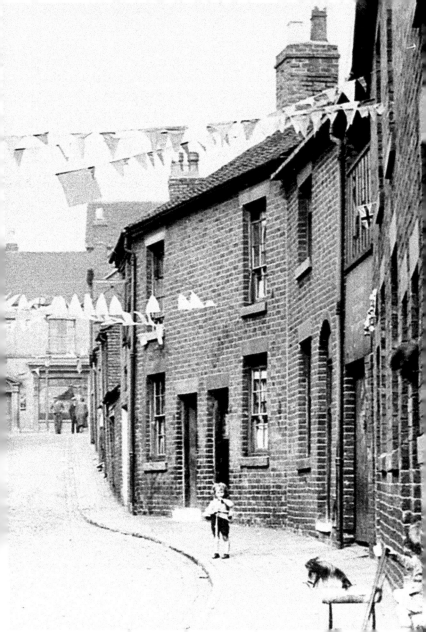

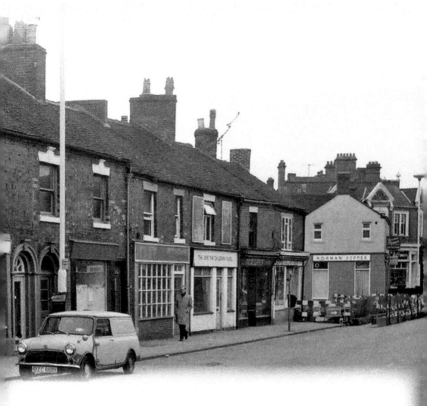

18. LIVERPOOL ROAD LOOKING
SOUTH, 1970s

Yet more nineteenth-century buildings demolished to make way for Newcastle's 'improved' transport system. Huge areas were cleared in the 1960s and '70s to create roads that allowed the majority of traffic to go around the town without actually stopping there. The properties in this photo as far as Corporation Street were demolished and replaced by a Sainsbury's in the 1980s. As with most old buildings, though, this was later demolished, leaving the site empty.

19. VIEW NORTH-WEST FROM ST GILES' CHURCH TOWER, 1930s

This view from St Giles' Church tower shows how densely packed early housing in Newcastle was. Development started with the castle at Pool Dam and spread outwards from there. The highest concentration of housing was originally in the areas of Upper and Lower Green, Holborn and the neighbouring streets. In the foreground is Froghall, and the L-shaped building in the distance is the Albemarle Almshouses. Most of the buildings in this image have since been cleared.

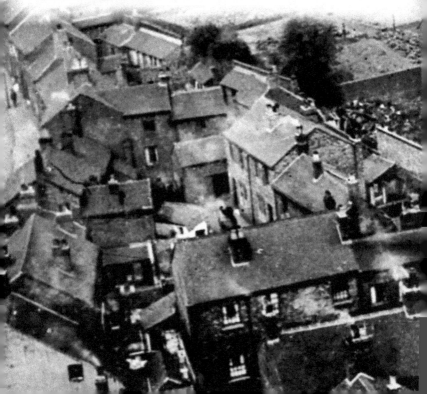

20. JUNCTION OF LOWER STREET AND POOL DAM, 1934

This view is virtually unrecognisable today, unless you can pick out the row of terraces in the distance with the old Orme Boys' School behind them. All of the other buildings have been demolished and this junction of Lower Street, Holborn, Pool Dam and Church Street is the site of a large roundabout today. The large, light-coloured building on the corner of Lower Street was the Fox & Goose, a pub hardly ever captured in photos.

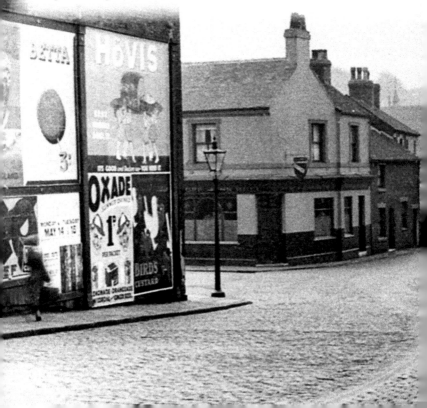

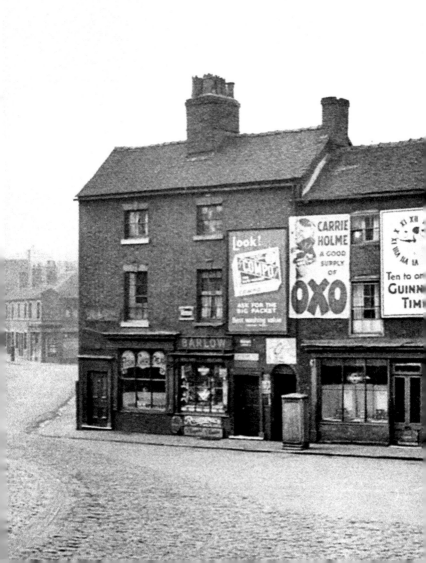

21. POOL DAM LOOKING TOWARDS CHURCH STREET, *c.* 1934

The only building from this photograph still visible today is St Giles' Church, the rest having been demolished a long time ago. The pub on the left is the John O'Gaunt Inn and the Savoy Cinema posters opposite advertise *Another Language*, dating this photo to *c.* 1934. In theory, the boy trying to cross the road could still be alive today and in his nineties; if so, does he know that he has been immortalised here?

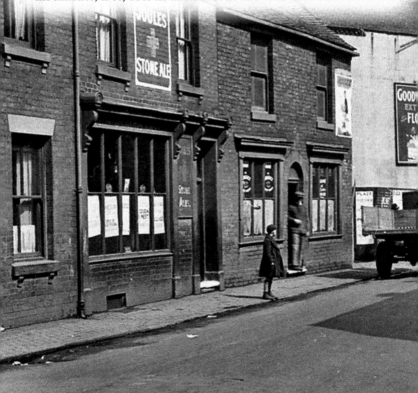

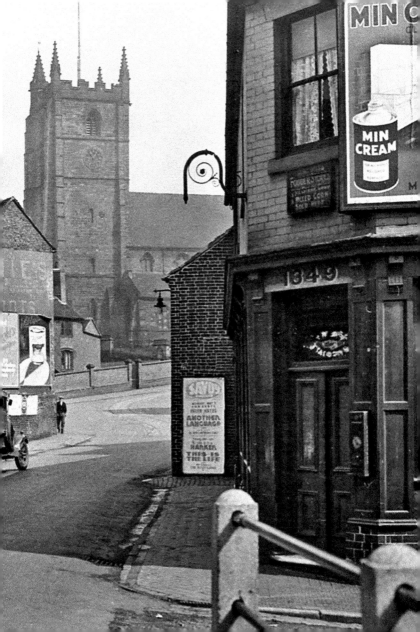

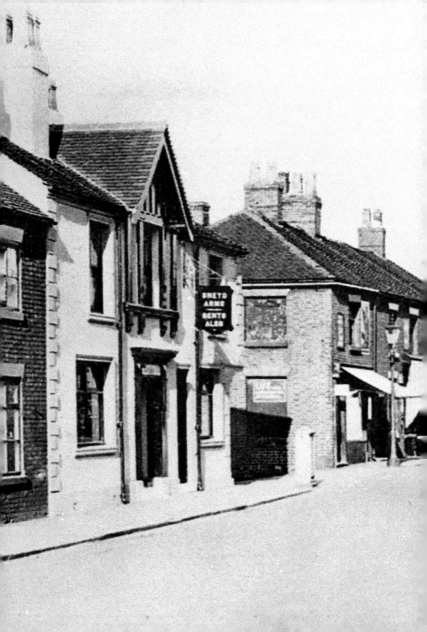

22. DEANSGATE AND DRAYTON ROAD, THE HIGHERLAND, 1920s

Only two of the buildings in this scene survive today: the Sneyd Arms in the foreground and the flat-roofed Lord Nelson Hotel in the distance. The Sneyd Arms is still named as such, but the other former pub is now an Asian restaurant and takeaway. All of the late eighteenth/early nineteenth-century shops and houses between the two were demolished in the 1960s, together with most of the buildings on the opposite side of the road.

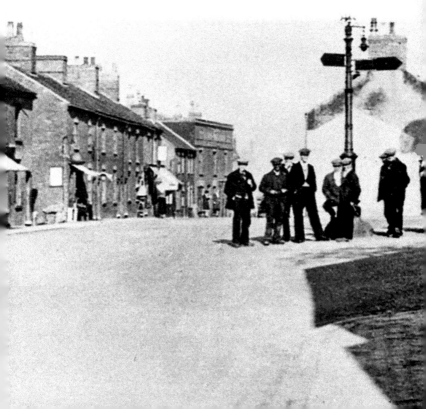

23. BLACKFRIARS, BLACKFRIARS BAKERY AND FRIAR STREET, EARLY 1960s

This scene looks very different today. The Ship Inn, advertising 'Double Diamond', stands in the path of the new A34 ring road and was swept away, together with many other buildings, to allow the road to pass from the Grosvenor roundabout to the one at the bottom of Church Street. Burgess's Blackfriars Bakery has gone, replaced by an Aldi supermarket. The cattle market on the right and the Sutherland Arms, out of shot on the left, have also gone.

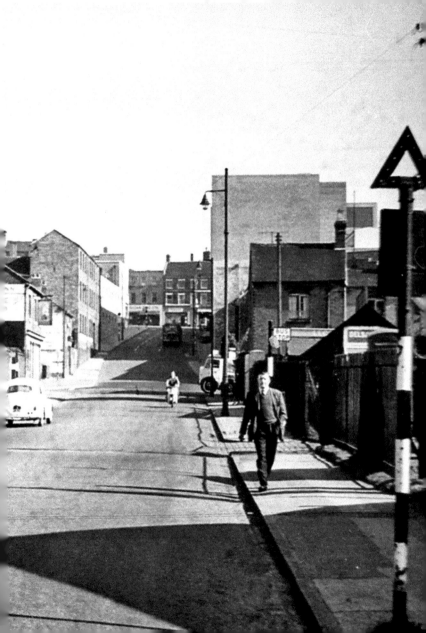

24. FRIARS STREET LOOKING TOWARDS LOWER STREET, 1937

Timber-framed buildings packed the left-hand side of Friars Street towards the crossroads with Lower Street – now part of the A34 ring road. The wooden gates below the two shops were to the old Market Tavern, later a Woolworths store. These buildings were all demolished between 1937 and 1954 when the new Woolworths store was erected on the corner of Friars Street and High Street; even today Newcastle people refer to this as 'Woolworth's Corner'.

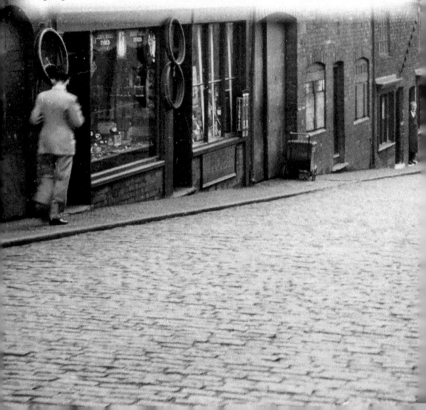

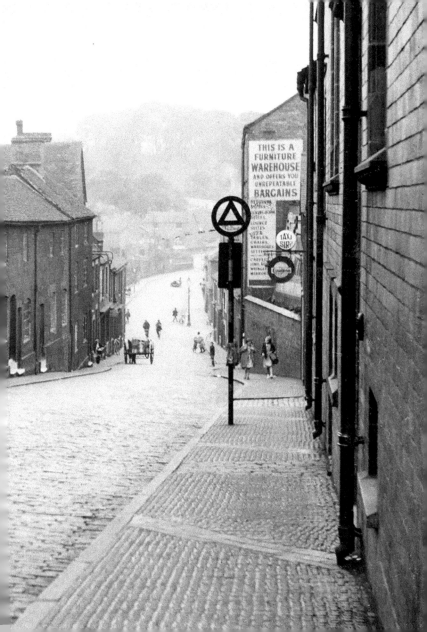

THIS IS A
FURNITURE
WAREHOUSE
AND OFFERS YOU
UNREPEATABLE
BARGAINS

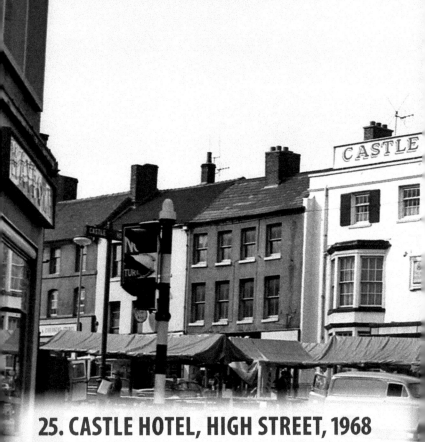

25. CASTLE HOTEL, HIGH STREET, 1968

In this photo the Castle Hotel approaches its closure after 180 years.
It had been altered significantly since it opened but the worst was yet
to come as, despite strenuous attempts by Newcastle Civic Society and
members of the public, a hideous new roof was added, the coaching
arch filled in and much of the original character of the building
was wiped away. The occupiers have changed many times since its
conversion to a Tesco supermarket.

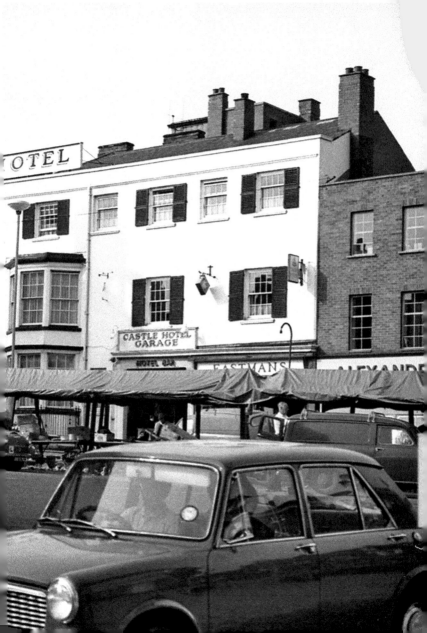

26. SHOPS ON THE HIGH STREET, 1870s

This photo by Edwin Harrison shows a row of late eighteenth- or early nineteenth-century shops on the south-west side of High Street, including the County Tea Warehouse. These buildings were clearly shown on a drawing from the 1839 issue of Cottrill's Police Directory. Today only one of these buildings survives, formerly Thomas Cook's travel agency but now occupied by the Midlands Air Ambulance Charity Shop.

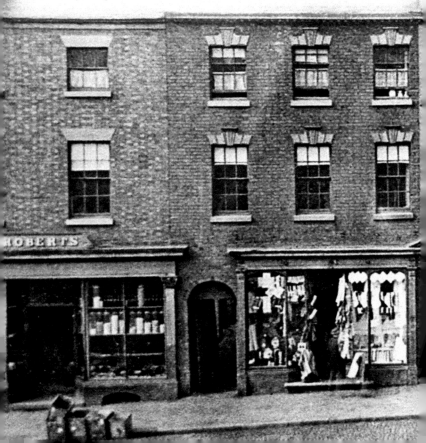

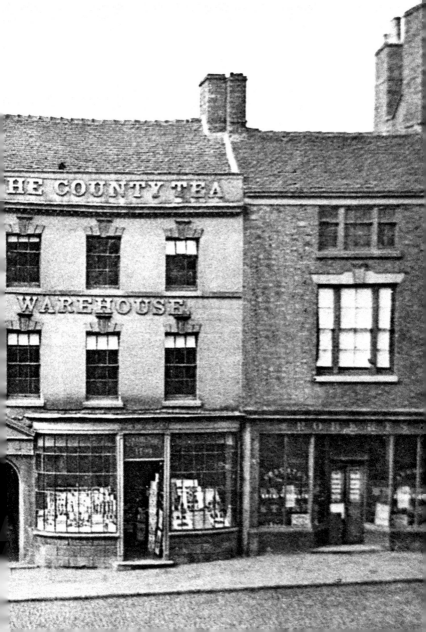

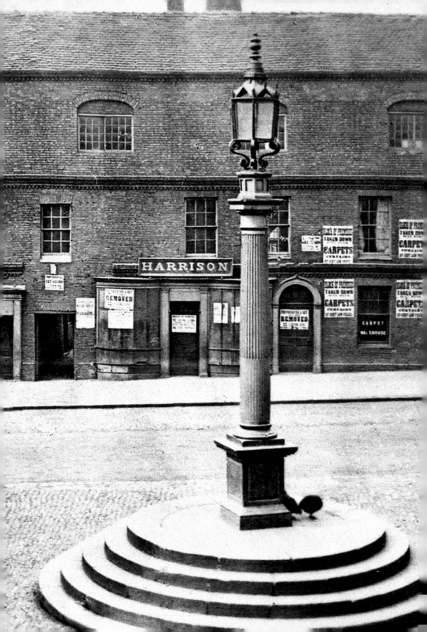

27. MARKET CROSS, HIGH STREET, c. 1873

Another Edwin Harrison photo shows the medieval market cross, which was restored in 1579 and another several times more recently, having had new lamps and a complete new shaft. In the row of buildings in the background Harrison's photographic studio can be seen, on which there are signs saying 'Removed to London Road'. Harrison had just moved from High Street to Liverpool Road and after him the business was continued by his son William and grandson Wilfred.

28. HIGH STREET LOOKING SOUTH PAST THE GUILDHALL, *c.* 1865

This photo is dateable to *c.* 1865 by the name of the landlord of the Rainbow Inn, Lewis Greaves. This is the only photo that shows the Weights & Measures Office at the south end of the Guildhall. This small building was removed in 1876 and placed in the centre of Red Lion Square (see No. 32). The timber-framed building located next to the Castle Hotel is also only known from this very early Harrison photograph.

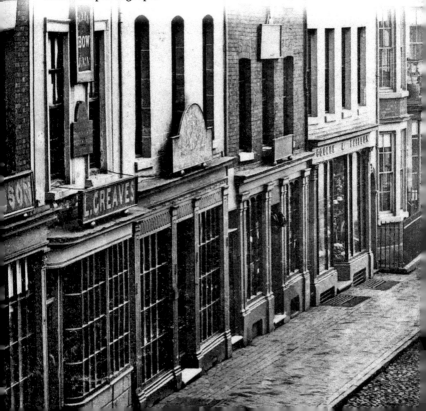

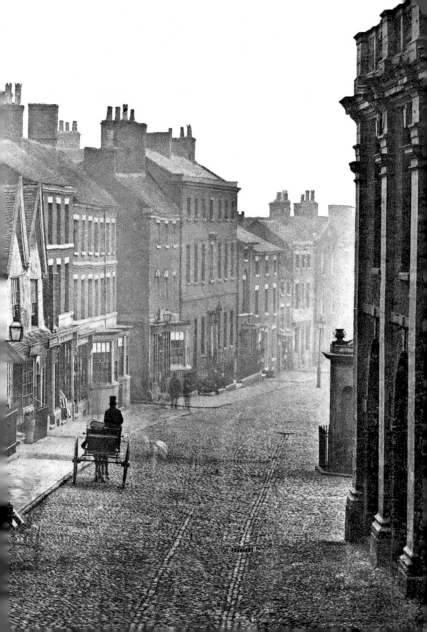

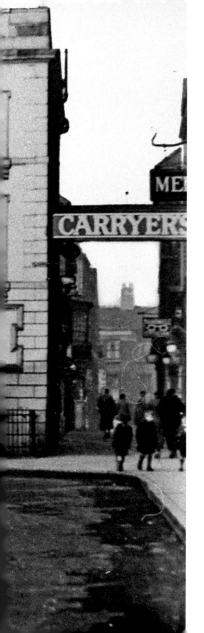

29. THE FORMER ROEBUCK COACHING INN, 1930s

Taken near the market cross, this image shows Newcastle's police station located on one corner of the old Roebuck Coaching Inn, which had been converted to a number of separate properties on all four sides. This building was demolished *c.* 1935 and replaced by the art deco Lancaster Buildings, which still stand there today. The first Newcastle Museum was located on the first floor of Lancaster Buildings until it moved to the Brampton *c.* 1956.

30. NEW STREET LOOKING TOWARDS THE MUNICIPAL HALL, *c.* 1920

Where the man on the left is standing was not Ironmarket but New Street until *c.* 1935 when the old Roebuck coaching inn, on the right of this image, was demolished. The large cast-iron and glass arcade outside Henry Whites men's shop can be seen on the left, which was welcome as a shelter from the rain when awaiting a Hanley bus; it was probably removed around 1970 and would probably not be permitted today.

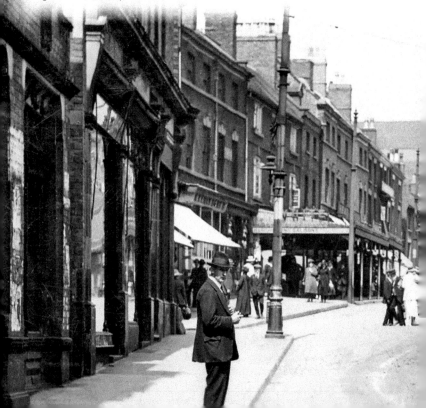

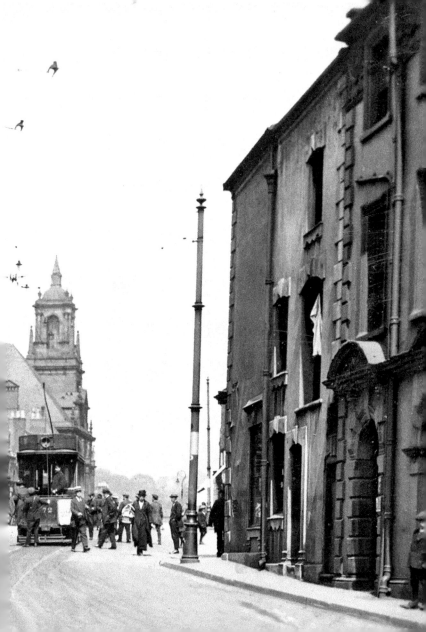

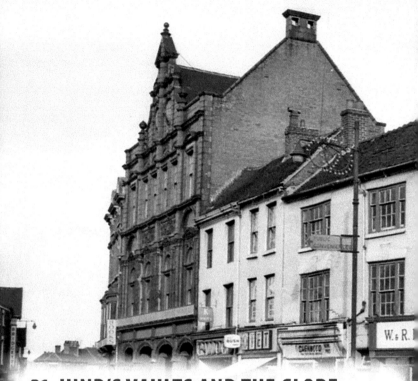

31. HIND'S VAULTS AND THE GLOBE HOTEL, RED LION SQUARE, 1960s

This photo by Bill Colville shows the properties opposite the Art of Siam. In the foreground is the timber-framed Hind's Vaults, and beyond it several Georgian shops. The tall building beyond is the Globe Commercial Hotel, built by Samuel Wilton in 1898 to replace a predecessor. It closed as a hotel in the 1950s and was converted into a large shop. This row was replaced by York Place, built in two phases in 1968/69.

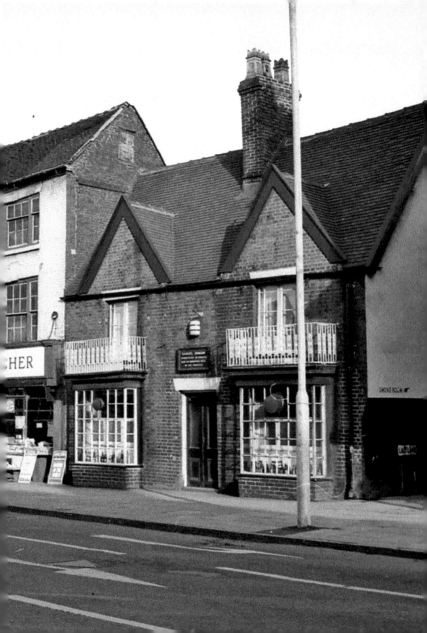

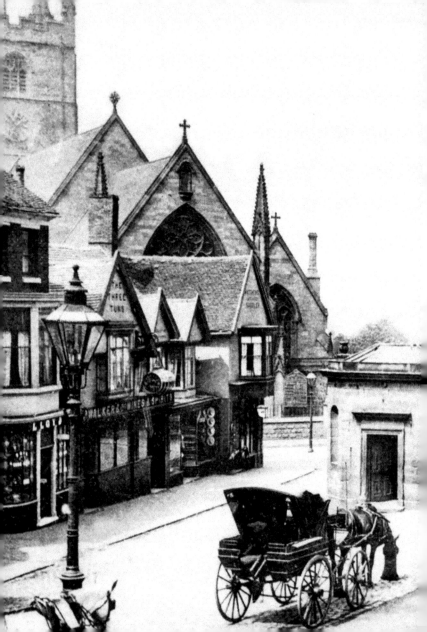

32. WEIGHTS & MEASURES OFFICE, RED LION SQUARE, 1890s

This photo of Red Lion Square was taken in the 1890s, before the Potteries Electric Trams were introduced to the town in 1900. It shows the Weights & Measures Office after it was moved from the south end of the Guildhall in 1876 (see No. 28). Not many years later the pace of life in Newcastle would change dramatically when the Ford Model T motor car and its competitors made their appearance in the town.

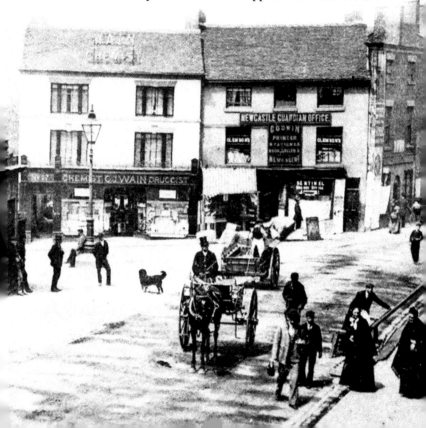

33. RIMMEL'S SHOP AND ST GILES' CHURCH, PRE-1873

This is **part** of **a** negative by Edwin Harrison, taken before the Georgian St Giles' Church was demolished and replaced by Sir George Gilbert Scott's Victorian Gothic version, **built between** 1873 and 1876. A photo album presented by Harrison to the church still survives containing immaculate photos of the **interior** of the Georgian church. The windows at Rimmel's, later occupied by Wain's Chemist's, contain displays of whole cheeses, tinned goods and 'Prime Old Sherry' and port.

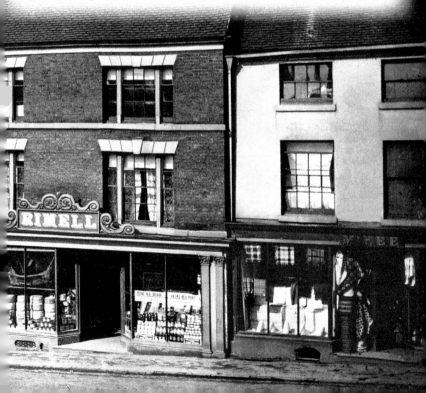

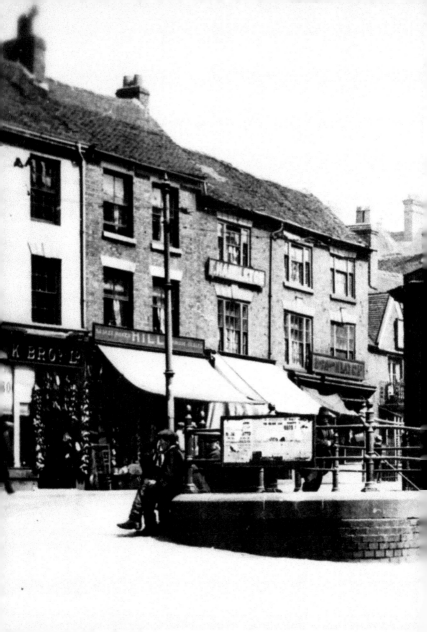

34. RED LION SQUARE FROM THE REAR OF THE WEIGHTS & MEASURES OFFICE, *c.* 1920

This is one of only two photos known that show the view from the rear of the Weights & Measures Office in Red Lion Square, proving that the photo is pre-1926. The photo reveals the presence of a sloping handrail leading to underground toilets, which could not be seen from the front. Every single building in the background has since been demolished, with the exception of the furthest away, the Guildhall, dating from 1715.

35. LAD LANE, *c.* 1968

The buildings on both sides of Lad Lane look exactly the same today as they did in this 1968 photo, but instead of the three-storey buildings straight ahead there is now the York Place Shopping Centre with its pedestrian walkway from Lad Lane to Merrial Street. This has recently been renamed Astley Walk after Philip Astley, the inventor of the modern circus, who was born in Newcastle in 1742. Shops here change hands frequently.

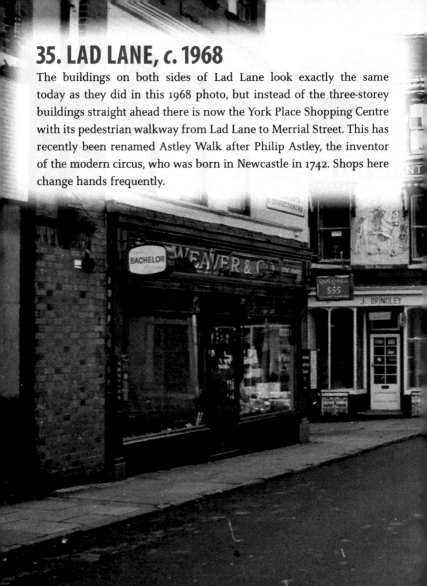

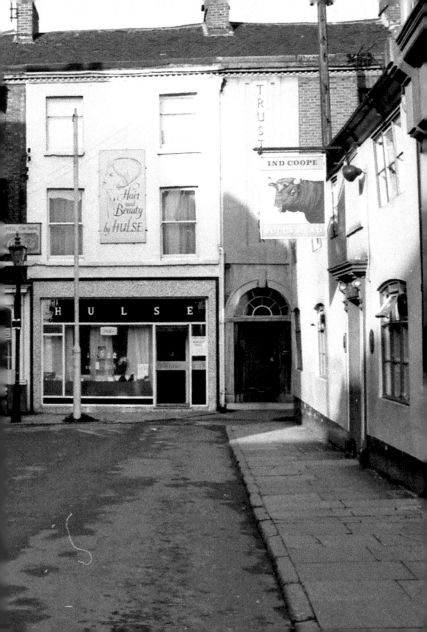

36. IRONMARKET LOOKING SOUTH-WEST, *c.* 1914

Only two of the buildings shown here have changed completely. On the left is the end of the old Roebuck coaching inn, by this time converted for shop use, and opposite on the right near to Burton's is the old post office, which was replaced by a bank when it was demolished. The Potteries Electric Tram company (PET) ran its services in Newcastle between 1900 and 1928, after which the street furniture and wires were removed.

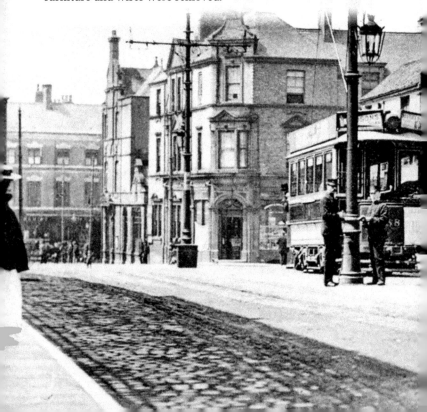

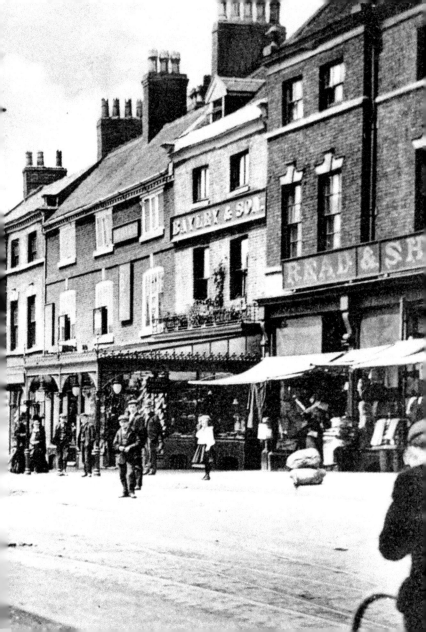

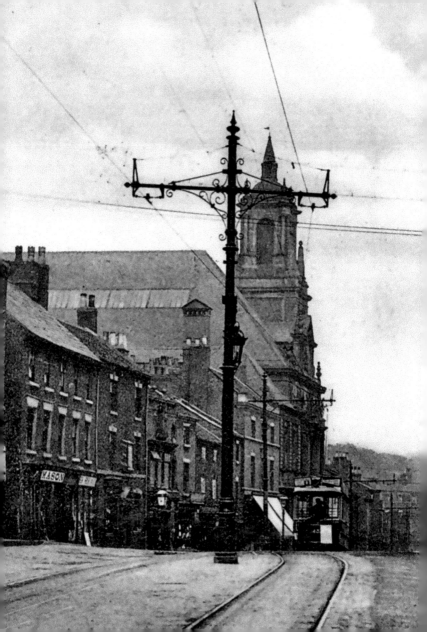

37. IRONMARKET LOOKING TOWARDS THE MUNICIPAL HALL, *c.* 1905

Another view taken during the tram age. This image shows how the Municipal Hall, designed by Leek architects William Sugden & Son, used to dominate the Ironmarket. The 'Muni', as it is known locally, survived for only a little over seventy years. The overall impression of Ironmarket is much the same as today, although No. 40, Slater's Bon Marche, has been replaced by a more modern building, occupied now mostly by charity shops.

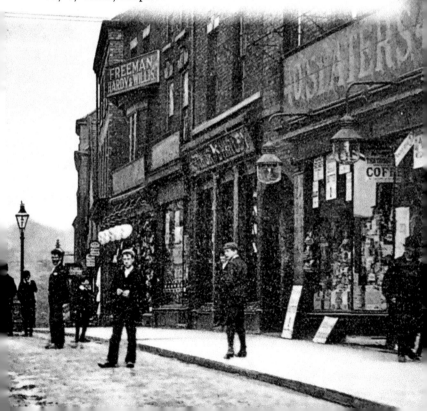

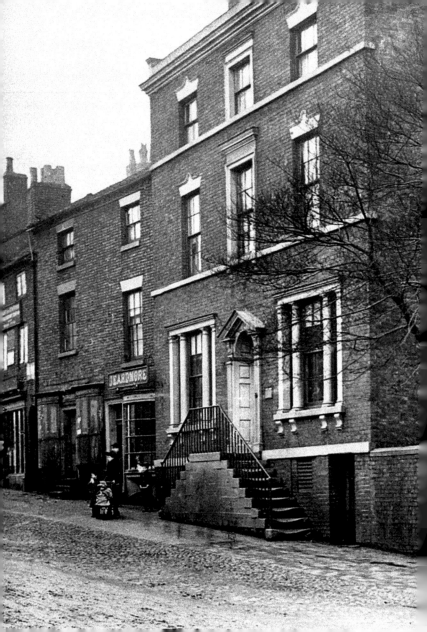

38. IRONMARKET, STEPS HOUSE, PRE-1888

This gentleman's residence, Steps House, looked far more impressive in the nineteenth century than it does today, butted up against the former Newcastle Public Library. This photo was taken before the Municipal Hall was built in 1888–90 and shows part of the garden to Arlington House, the grand detached house demolished to make way for the 'Muni'. The road level in Ironmarket has been raised considerably, rendering the steps unnecessary.

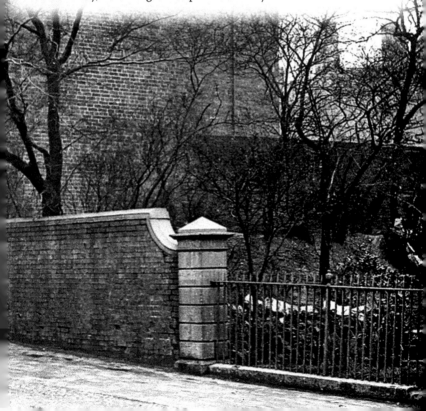

39. IRONMARKET, ST GILES' RECTORY, c. 1900

Like Steps House on the previous page, this beautiful house built in 1698 at the bottom of Ironmarket for St Giles' Rector Egerton Harding still stands today. It hasn't escaped alteration and in 1926 began ten years as a medical centre before being extended and converted for shop and office use. Today it goes by the name of Rectory Chambers and its divided ground floor houses a long-standing newsagent and two other properties – one a steakhouse.

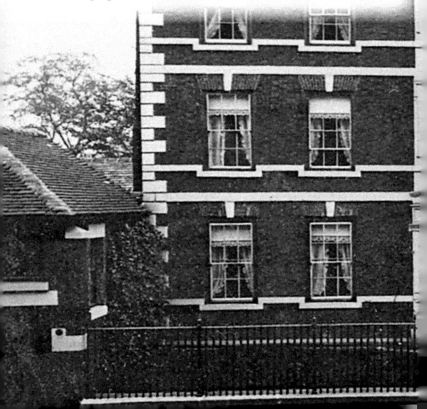

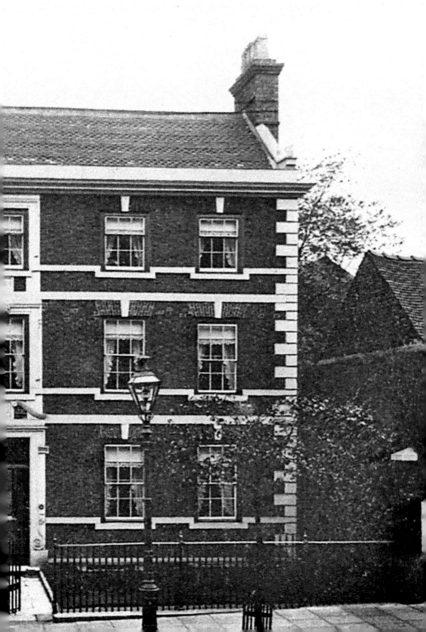

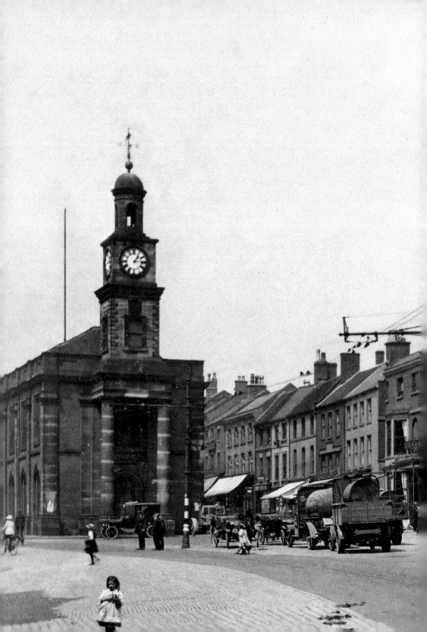

40. PENKHULL STREET/ HIGH STREET, 1920s

This 1920s view of High Street and the Guildhall from Penkhull Street is most interesting, not for something that it shows, but something that it doesn't – Hassell Street. On the extreme right is the National Provincial Bank, now NatWest, but to its left is not Hassell Street as today, but the Home & Colonial Tea Stores and a tea shop. These were demolished *c.* 1930 to permit Hassell Street to reach High Street.

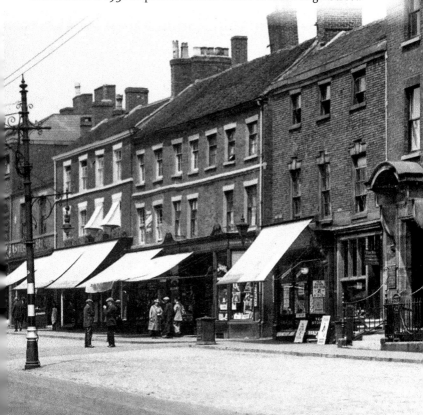

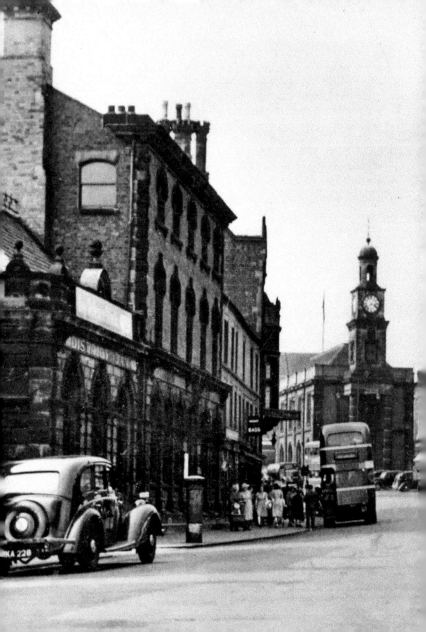

41. PENKHULL STREET LOOKING NORTH, *c.* 1948

This view was taken before Penkhull Street was renamed High Street in 1954. Before the A34 ring road was constructed this was the main north–south route through the town, and on market days heavy lorries and buses would have to negotiate the town's ancient street market. Every building on the left would be demolished by the late 1960s, including the Liverpool & Manchester District Bank and the Red Lion pub, where the Vue cinema stands today.

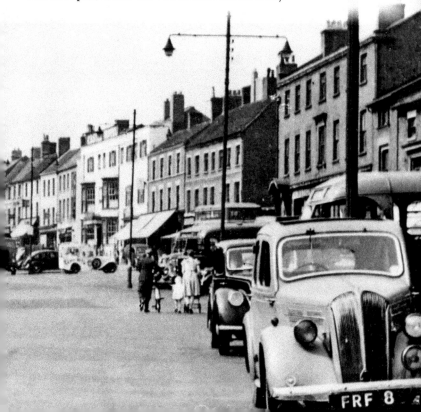

42. PARADISE STREET, c. 1935

Never the most appropriately named street, Paradise Street today is located between the D-Licious takeaway and Cash Converters and is now home only to Jobcentre Plus and Blakey's Café Bar. In 1912 there were twenty-two households here in poor-quality terraces. In 1937 the street was cleared, the majority of residents being relocated to Beattie Avenue in Cross Heath. A series of photographs in Newcastle Museum show their possessions being fumigated to eliminate lice and fleas.

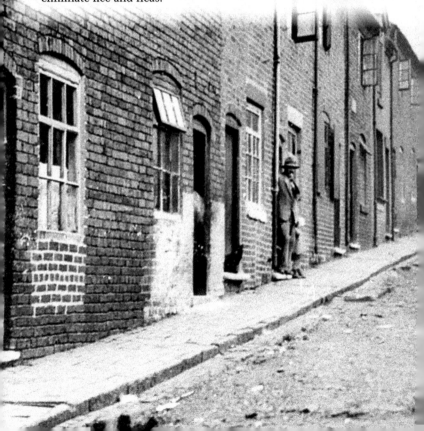

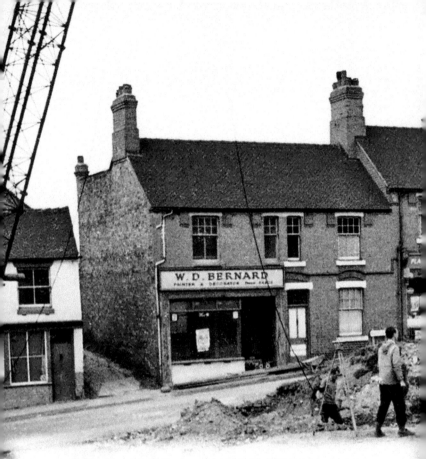

43. SOUTH END OF HIGH STREET, 1964

Taken just prior to the digging of the sunken roundabout and the creation of the A34 ring road, the narrow building to the left of Geo. Hollins & Sons ironmonger's shop bearing the date '1897' is the Spread Eagle public house. Today this is called the Black Friar and is the end building on that side of High Street. All the houses and shops to its left were demolished soon after this photo was taken.

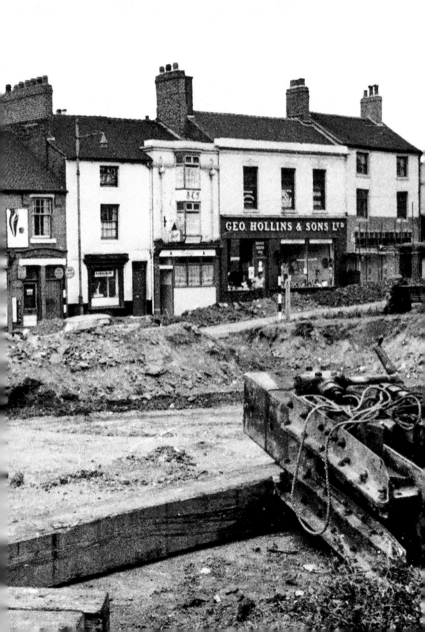

ACKNOWLEDGEMENTS

My sincere thanks to the late William (Bill) and Marjorie Colville, Aidan Gillen, Newcastle-under-Lyme Borough Museum, Gregor Shufflebotham, Sue Fox and anyone else who contributed photographs or information to make this book possible. While every effort has been made to ensure accuracy and to gain permissions for the pictures used, for any error or omission I can only offer my sincere apologies.

BY THE SAME AUTHOR

Newcastle-under-Lyme Through Time (co-author; 2012)
Leek Through Time (2012)
Leek Through The Ages (2013)
Rudyard Rushton and The Roaches Through Time (2013)
Cheddleton & District Through Time (2014)
Bagnall, Endon, Stanley & Stockton Brook Through Time (2015)
Bucknall to Cellarhead Through Time (2016)
Secret Leek (2016)
Leek: A Historic Pub Crawl (2018)

Also available from Amberley Publishing

NEIL COLLINGWOOD & GREGOR SHUFFLEBOTHAM

NEWCASTLE-UNDER-LYME

THROUGH TIME

This fascinating selection of photographs traces some of the many ways in which Newcastle-under-Lyme has changed and developed over the last century.

978 1 8486 8306 8

Available to order direct 01453 847 800

www.amberley-books.com